IMAGES
of America

RAPID CITY
AMERICA'S PLAYGROUND

Rapid City is the starting place for those who visit the Black Hills—from its lofty peaks and pine-scented forests, one can see anywhere from here. (Courtesy of Ken Schoenhard.)

On the cover: Visitors to Rapid City and the Black Hills can find scenic vistas from all directions. This view was photographed in the Sykvan Lake region. (Courtesy of Bill Groethe.)

IMAGES
of America

RAPID CITY
AMERICA'S PLAYGROUND

Bev Pechan and Bill Groethe

ARCADIA
PUBLISHING

Published by Arcadia Publishing
Charleston, South Carolina

Printed in the United States of America

Library of Congress Catalog Card Number: 2007936198

For all general information contact Arcadia Publishing at:
Telephone 843-853-2070
Fax 843-853-0044
E-mail sales@arcadiapublishing.com
For customer service and orders:
Toll-Free 1-888-313-2665

Visit us on the Internet at www.arcadiapublishing.com

Trout were not native to the Black Hills, but Cleghorn Hatchery in Rapid City and other fisheries in the Black Hills have helped to create an angler's paradise here. (Courtesy of the Bell collection.)

CONTENTS

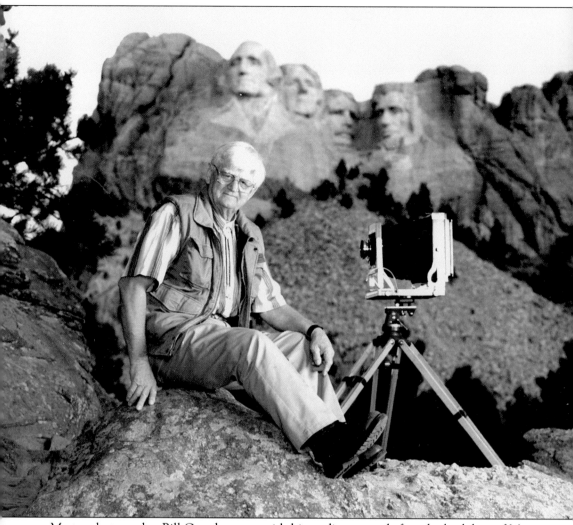

Master photographer Bill Groethe poses with his studio camera before the backdrop of Mount Rushmore. He began his 70-year career as a photographer by apprenticing to Bert Bell during the early construction of Mount Rushmore as a youth and has been capturing the memorial on film ever since. (Courtesy of Bill Groethe.)

INTRODUCTION

Tourism's finest hour began with the explosion of sightseers following the end of the Great War, also called World War I. In the 1920s, a new freedom of spirit spread across America like wildfire. People wanted to stretch . . . and to learn. The advent of the automobile made this feasible for the masses. Popular destinations at the time included Yellowstone National Park and the Black Hills of South Dakota. The Black and Yellow Trail, beginning at Brookings, crossed the Missouri River at Pierre and entered the gateway to the Black Hills at Rapid City, en route to Yellowstone. The entire road system was known as the Chicago, Black Hills and Yellowstone Park National Highway. There were a number of other well-traveled byways: the Washington Memorial Highway crossed the state through the south, the Yellowstone National Trail crossed the state to the north, and the Meridian Highway ran north and south at the eastern end of the state. The Custer Battlefield Highway from Montana ran through Rapid City en route to its eastern destination, and there were two additional tourist routes: the Black Hills Lincoln Loop, a part of the Lincoln Highway, which crossed the Midwest; and the Belt Line, or Circuit Route, a series of roads that ran from Rapid City north to Deadwood, then south to Hill City, Custer, Sylvan Lake, Wind Cave, Hot Springs, then north again through Buffalo Gap, Hermosa, and back to Rapid City. One really could get there from here!

American patriotism has always played a part in traditions surrounding Rapid City. In the 1890s, "The Star-Spangled Banner" was first played at Fort Meade as a national anthem. Mount Rushmore, America's shrine of democracy, was created during the Great Depression and America's space program began with the experimental Stratobowl balloon flights just beyond Rapid City in 1934 and 1935. Following World War II, the central Black Hills was a considered location for the new United Nations organization. Today, Rapid City's "City of Presidents" arts project and President's Park in the northern hills continue to celebrate the region's rich heritage. (Courtesy of Bill Groethe.)

One

THE EARLY CENTURY

This "Wild and Wooly West" postcard dates to the early 1900s. Printed by Tammen in Denver, Colorado, it shows playful Native American boys with a couple of cowboy innovations—a toy gun and holster and broad-brimmed ranger hats. Cowboy and Native American themes have been perennial favorites of tourists who visit the West. (Courtesy of Bev Pechan.)

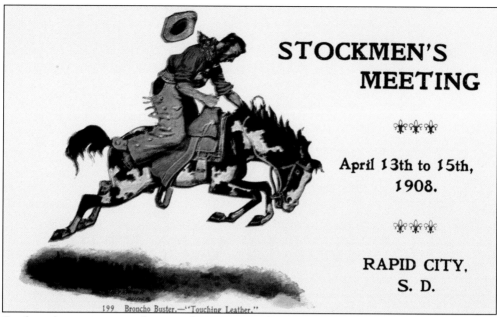

Stockmen's meetings were the annual conventions, beginning in 1891, held in Rapid City by the South Dakota Stockgrower's Association. This postcard from 1908 shows a cowboy in work gear enjoying a ride on a pitching bronco. (Courtesy of Bev Pechan.)

Members of this little gathering of frontier horsemen test their skills against mustang ponies who would rather not have cold saddles on their backs in early morning. (Courtesy of Bev Pechan.)

PUBLISHED BY S. A. LONGENECKER, RAPID CITY, S. D.

9869 St. Joseph Street, Rapid City, S. D.

This view of Rapid City in the early 1900s looks east from St. Joseph Street. The domed building on the left is the U.S. weather station. The wide street could accommodate many horses and heavy wagons and is how it would have looked to visitors back then. (Courtesy of Bev Pechan.)

A hotly contested Stockmen's Day race heads toward the gap. The large banner advertises Bowles Commission Company, with offices in Chicago, Kansas City, Omaha, Sioux City, and St. Paul. A crowd has gathered on boxes, far right, for a better view. (Courtesy of Bev Pechan.)

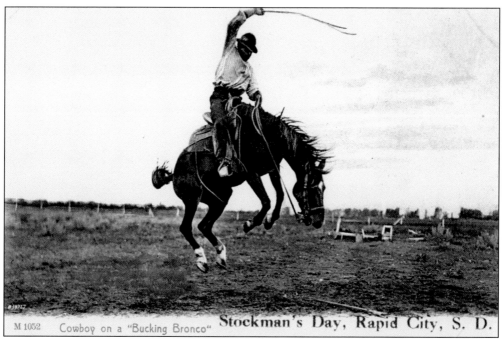

M 1052 Cowboy on a "Bucking Bronco" Stockman's Day, Rapid City, S. D.

A Native American cowboy shows off for the camera. The horse is wearing a standard bridle with a bit, indicating that this may have been some sort of "buck-out" on a bet. Cowboys often rode bucking horses before crowds in downtown areas on wagers. Now and then one would buck through a plate glass store window or enter by one door and leave through the other. (Courtesy of Bev Pechan.)

Free For All Pony Race
Rapid City S. Dak.

A free-for-all pony race takes place on west Main Street during Stockmen's Days, with Sweeney Hardware shown at right. Some entrants wore women's clothing to make it more fun. Newspapers said of the Sioux City delegation, "The party will occupy a special car which will be appropriately decorated with Sioux City banners and everybody will hustle among the stockgrowers in the interests of the Sioux City market." (Courtesy of Bev Pechan.)

This *c.* 1910 R. R. Doubleday postcard says, "Bolton taking a bad spill" on a bareback bronc. Local ranches provided entertainment galore for spectators who parked their automobiles in a circle around contestants, keeping the act on the inside. It worked most of the time. (Courtesy of Bev Pechan.)

Another weekend rodeo draws a large crowd. The "cowboy's delight" may not be all that pleasant. The horse is blindfolded and is probably an outlaw. Three men are closing in, just in case. (Courtesy of Bev Pechan.)

An admiring tourist casts an approving glance over this dancer's costume. The headdress is a roach made from the manes and tails of horses. Around his shoulders, strings of mirrors and animal teeth round out a wardrobe of coin-studded belt, dance bells, leggings for modesty, and pieces of buffalo fur–trimmed beaded or quilted moccasins. (Courtesy of Bev Pechan.)

Participants from the Sioux nations come from miles around bringing families, treasured finery, and pets to enjoy days of dancing, feasting, games, and betting contests, like horse races and rodeos. Some of the women's dresses have heavy shell trim and can weigh as much as 40 to 50 pounds. (Courtesy of Bev Pechan.)

14

Sioux sham battles were an entertaining and action-packed part of Stockmen's Days. This 1910 postcard shows costumed Native Americans getting ready to attack a cowboy camp in Rapid City in an open area south and east of present Mount Rushmore Road, or Eighth Street. (Courtesy of Bev Pechan.)

A popular Lakota elder, Little Chief was a familiar figure at many powwows. (Courtesy of Bev Pechan.)

The cadet shown attended the Rapid City Indian School, headed by Chauncey Yellow Robe. These young men and women were disciplined students, whose skills were often showcased through public events. The school operated in the late 1800s and early 1900s in southwestern Rapid City, which is now the site of the Soo San Indian Health Care Hospital. (Courtesy of Bev Pechan.)

Young Lakota ladies from the Rapid City Indian School demonstrate their agility at using Indian clubs in their physical training routines. At left is the arched facade of the Tom Sweeney Hose Company on west Main Street looking toward the gap. A brass band plays in the background. (Courtesy of Bev Pechan.)

"Indian School in Red Cross parade," says the caption on this postcard dating to Word War I. The photograph was taken looking northeast toward the corner of Main and Sixth Streets. The large building, formerly Jack Clower's saloon, is the present home of Prairie Edge. Across the street is Tittle's grocery, now a parking lot. (Courtesy of Bev Pechan.)

This postcard is titled "A High Flyer" and was mailed from Viewfield, South Dakota, to Rapid City on June 16, 1908. The message reads, "Hello! Here I am having a good time. I have been visiting every day." (Courtesy of Bev Pechan.)

Eager cowboys ready for the steer-roping contest at a western roundup. Both cowboys and Native Americans are readying their ropes for the big event, which may have been on Sunday, as the rider second from left is wearing a white shirt, necktie, and fedora hat. (Courtesy of Bev Pechan.)

A group of cowboys plays cards. The painted Black Hills cabin backdrop sets the scene for a "friendly" card game—typical wrangler fun in the early 1900s. The angora chaps are called "woolies." Tourists are still photographed in western costume here today. (Courtesy of Bev Pechan.)

This is what a real card game might look like when a cowboy had a little down time. Numerous ranches surrounded Rapid City and the fellows looked forward to Saturday nights in town. (Courtesy of Bev Pechan.)

Fishing was a real challenge without today's streamlined accessories. This angler's pole reaches nearly across the stream. The card's sender is preparing a new home for his Illinois bride in the Black Hills. He writes, "Have decided to use 4 rooms instead of 3 so you can have a sink . . . I will do the best I can for you out here." (Courtesy of Bev Pechan.)

Weekend runs carried passengers to all points north and south of Rapid City. Adventurers have stepped out of cars on the Burlington, Missouri River and Nebraska tracks to get a breathtaking view of spectacular Spearfish Falls. In 1904, this company merged with four others to form the Chicago, Burlington and Quincy Railroad. (Courtesy of Bev Pechan.)

As seen in this 1913 postcard, the Black and Yellow Trail was a system of often muddy ruts that linked the Black Hills and Yellowstone Park, nearly 500 miles distant. Black and yellow were also chosen as the colors for the 16,000 license plates sold in South Dakota in 1914. The invention of the automobile coincided with the closing of the frontier. (Courtesy of Bev Pechan.)

This road through the Needles was considered a superhighway by its apparent width. Yet early automobiles rarely traveled alone in these remote areas, for there was no way to communicate with the outside world should a breakdown occur. (Courtesy of Ken Schoenhard.)

The Rapid City, Black Hills and Western (also known as the Crouch Line) touring car is going up Rapid Canyon. Popular for picnickers, berry pickers, and fishermen, riders could hop on and off at will. The Crouch Line was called the "crookedest railroad in the United States," as it crossed and recrossed Rapid Creek 105 times in 34 miles. (Courtesy of the Bell collection.)

Pictured are the Crouch Line tracks as seen along Rapid Creek in Dark Canyon, above Rapid City. The writer tells her mother in Minnesota on September 14, 1912, that it is "awful cold here this morning." Fall temperatures in the Black Hills can change drastically in a matter of minutes or hours. (Courtesy of Bev Pechan.)

"Our convention is over and we are visiting points of interest in the Hills and we are enjoying our try," says this postcard mailed June 28, 1912. Wedge Rock at Sylvan Lake is about 30 miles below Rapid City, indicating that these sightseers have probably taken the excursion train. (Courtesy of Bev Pechan.)

Rock formations surrounding Rapid City were plentiful and well visited by early tourists. This natural bridge is not widely known today, but a few have been discovered quite by accident. Rushing waters from an early time carved many unusual natural works of art in the Black Hills.(Courtesy of Bev Pechan.)

Harney Peak, elevation 7,242 feet, and its U.S. ranger station (shown here before 1920) is the highest point between the Rocky Mountains and the Swiss Alps. It was first climbed by George Armstrong Custer on his Black Hills expedition of 1874, but he did not reach the summit, stopping a short distance below. (Courtesy of Ken Schoenhard.)

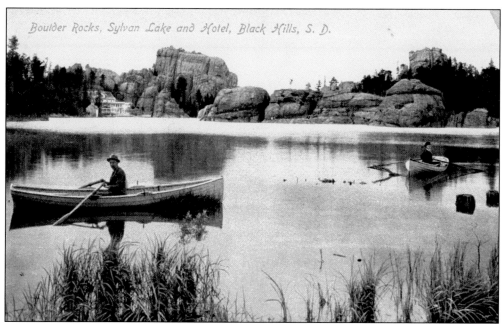

Boulder Rocks, Sylvan Lake and Hotel, Black Hills, S. D.

Rowboats on Sylvan Lake were a popular attraction for vacationers and weekenders from Rapid City. This pre-1920 postcard shows the original Sylvan Lake Hotel and the Boulder Rocks area. Stagecoaches ferried guests to the resort in its earlier days. (Courtesy of Bev Pechan.)

189. On the Trail to Harney Peak aboard a Burro,
Black Hills, S. D. "See America First."

Trusty "mountain canaries," these sure-footed burros carried riders of all sizes up the rugged trail to Harney Peak as seen here in 1911. Jeeps later plied the trail, but today the area is accessed by foot, starting at the Sylvan Lake trailhead, a four-hour trek. (Courtesy of Bev Pechan.)

Hangman's Hill, photographed looking east about 1910, was the scene of a triple hanging of horse thieves in 1877. The original hanging tree may be on the right. The Rapid City spot is clearly visible today high above the Baken Park shopping area. (Courtesy of Bev Pechan.)

DAY IN AND DAY OUT

Day in and day out, Dodge Brothers Motor Car serves its owners faithfully and at low cost.

This is because Dodge Brothers have consistently built their product more staunchly than strict manufacturing practice requires.

Employing only the finest materials, they have insisted upon an exceptional margin of excess strength in every part that takes a major strain.

SEIM AND SMITH MOTORS, INC.
Main Street RAPID CITY

Seim and Smith Motors, Rapid City, touted the new Dodge Brothers motorcar. With the popularity of the automobile, times were changing, and it was becoming necessary to find more and more ways to entice the traveling public. (Courtesy of Bev Pechan.)

Two

THE 1920S

Lincoln Borglum is seen taking a measurement of Thomas Jefferson's head in the sculptor's studio below the site of the Mount Rushmore project. Full-length figures of George Washington, Jefferson, and Abraham Lincoln were revised to busts, with the face of Theodore Roosevelt added later. The scale was a ratio of one inch on a model to a foot on the mountain. (Courtesy of the Bell collection.)

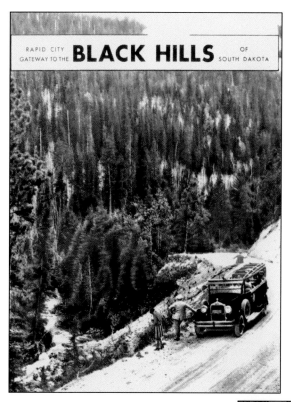

This promotional book put out by the Chicago and North Western Railway contains many Bert Bell photographs. As photographer for the firm's publicity department in 1927, Bell knew that tourism would be one of the area's biggest assets, and he stayed to be a part of it, opening his own studio in Rapid City. (Courtesy of Ken Schoenhard.)

The back cover of the publication is also promoting rail travel. Alex C. Johnson, builder of the Hotel Alex Johnson, is listed here as the Chicago and North Western's representative in Rapid City. (Courtesy of Ken Schoenhard.)

The Hotel Alex Johnson was started in 1927, coinciding with the start of work on Mount Rushmore, and completed a year later. This showplace of the West was a landmark from the beginning, towering above the eastern prairie and designed in Native American and art deco themes, a look it retains today as it anchors downtown Rapid City's historic district. (Courtesy of the Bell collection.)

Also a popular Rapid City hostelry, the original Harney Hotel is pictured here. The large entrance features a confectionery advertising "fountain service" with ice cream and 5¢ coffee. Touring buses picked up fares in front also. (Courtesy of Ken Schoenhard.)

Peter Norbeck, with state historian Doane Robinson, was the visionary who conceived the idea of large sculptures in the Black Hills. A governor and state senator, Norbeck established Custer State Park and walked or rode horseback through the southern Black Hills to personally lay out the scenic highways enjoyed by millions ever since. (Courtesy of the Bell collection.)

Tunnels on Needles Highway were a part of Norbeck's plan, and he saw to it that they framed views of Mount Rushmore at every opportunity. (Courtesy of the Bell collection.)

The game lodge was built in 1927 under the direction of C. C. Gideon, a Minneapolis architect who was instrumental in much of the infrastructure within Custer State Park, America's largest state park, at 71,000 acres. The game lodge became the summer White House for Pres. Calvin Coolidge in 1927 and Pres. Dwight D. Eisenhower in 1953. (Courtesy of Bev Pechan.)

Before Custer State Park was established in 1919, Peter Norbeck first introduced a state game preserve in 1913 in the manner of a drive-through zoo. Buffalo from pioneer rancher Scotty Philip were introduced here and are the nucleus of today's park herd. The antelope are pictured in 1923. (Courtesy of Ken Schoenhard.)

Mount Coolidge, a fire lookout tower in Custer State Park, was constructed of logs at an elevation of 6,400 feet. It continues to be in use today as an active observation post. (Courtesy of Bev Pechan.)

Camp Galena in Custer State Park was a tent city concept for tourist parks that sprang up in the 1920s. Considered state-of-the-art for the period, the huge shelters could house entire families. Rapid Citians took advantage of weekend escapes to fish and wade in fast-moving streams where it was uncrowded and cooler. (Courtesy of Bev Pechan.)

Fiery Gutzon Borglum, Mount Rushmore's creator, works over portions of his George Washington model. When he got it right, he telephoned his instructions to workers on the mountain, who then set charges of dynamite and drilled with jackhammers to "carve" the memorial. Workers were employed just to daily sharpen the 400 drill bits used. (Courtesy of the Bell collection.)

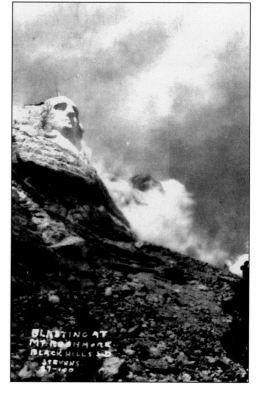

Blasting behind the head of Washington is probably work on the face of Thomas Jefferson, originally begun on the opposite side of Washington. Unstable rock caused that surface to be dynamited off. Also as a result of fracturing, Washington's head was cut back 25 feet into the granite rock bed. (Courtesy of Bev Pechan.)

Three

THE 1930S

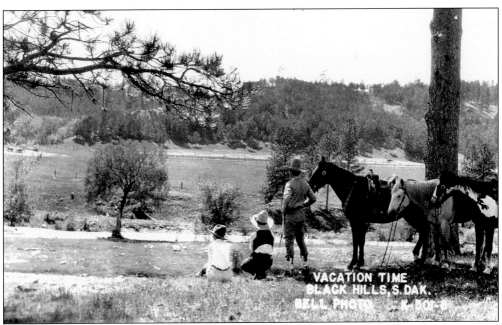

Real-life cowboy Russ Madison saw the potential of dude ranching in addition to his jobs as rancher, trail boss, and rodeo producer. Tourists wanted to experience the Old West and the Madison ranch near Rapid City was a hub of activity for nearly a century. (Courtesy of the Bell collection.)

This view of Rapid City in the late 1930s looks east toward the South Dakota School of Mines. The Hotel Alex Johnson is seen at the upper left. St. Joseph and Main Streets are the principal routes of travel and are not paved. (Courtesy of the Bell collection.)

A similar view shows a hairpin curve on Skyline Drive. Even on a good weather day, it was a white-knuckle ride for most motorists, but the view was great. Except for the dirt road, not much has changed. (Courtesy of the Bell collection.)

Tourists to Rapid City in the 1930s might have looked like this Illinois couple who decided to visit family and see the sights. Hard times during the years of the Great Depression and dust bowl found farmers who had no crops with time on their hands. Nobody had much money, but much really was not needed then. (Courtesy of Bev Pechan.)

This Standard Oil station was located at Sixth and St. Joseph Streets, kitty-corner from the Hotel Alex Johnson. U.S. Highways 14 and 16 and South Dakota Highway 79 converged and ran through the length of downtown Rapid City. (Courtesy of the Bell collection.)

The Benevolent and Protective Order of the Elks No. 1187 in Rapid City was known for its involvement in civic affairs and sponsorships. The 1912 Elks building is across Sixth Street from the Hotel Alex Johnson. Club rooms were upstairs. The street level housed the Silver Star Bar, Western Union, a newsstand and party shop, the Elks Theater, and a hardware store. (Courtesy of the Bell collection.)

Elks conventions brought hundreds to Rapid City. Parades, feasts, and fun headed the agenda. Here the local distributor for Grain Belt beer has set up a patriotic display in the banquet room following Prohibition. Quart-size bottles and cone-top cans are part of the offering. (Courtesy of the Bell collection.)

Traffic snarl-ups seemed to be a Rapid City phenomenon. Traffic lights just made things worse, for drivers paid little attention to them. Making matters worse yet was the fact that all main routes of travel ran through the center of town. (Courtesy of Bev Pechan.)

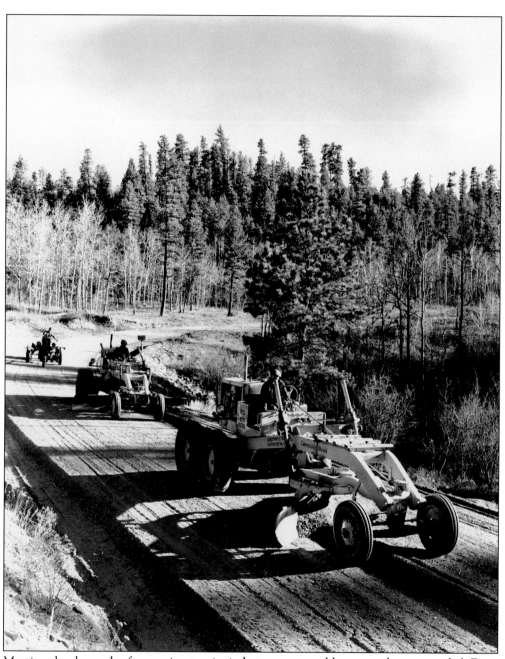

Meeting the demands of a growing tourist industry, more and better roads were needed. From the late 1920s and throughout the 1930s, scores of men from local Civilian Conservation Corps camps helped blaze the way. This road is shown at the western end of South Dakota Highway 87 (Needles Highway), just below Mount Rushmore. (Courtesy of the Bell collection.)

The ingenuity of the famed pigtail bridges was part of C. C. Gideon's legacy. Located on U.S. Highway 16A below Keystone, they allow for sudden rises in elevations that would otherwise make the drive impossible. (Courtesy of the Bell collection.)

Custer State Park pigtails are marvels of engineering, as can be seen here by their log infrastructure, and are still in use today. Constructed during the Depression years, Civilian Conservation Corps laborers used native materials and during the same period erected log and stone buildings, picnic shelters, stairways, overlooks, and signage. (Courtesy of the Bell collection.)

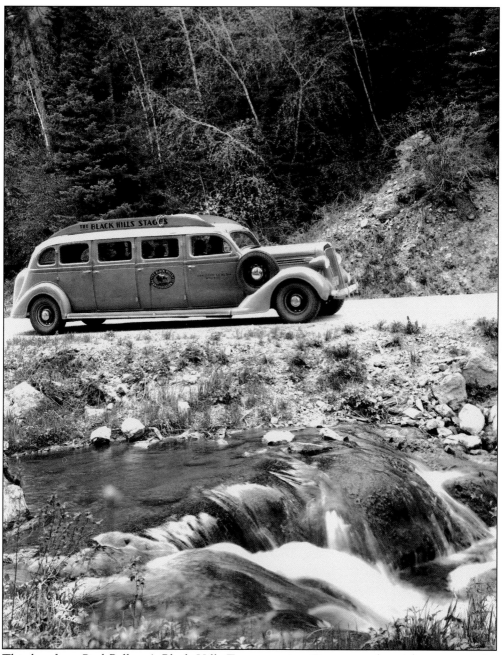

This bus from Paul Bellamy's Black Hills Transportation Company takes sightseers over the Hill City Road to Keystone, along Battle Creek. Bellamy's company was one of several that headquartered in the street front business section of the Hotel Alex Johnson. (Courtesy of the Bell collection.)

Black Hills scenery and pine-scented air were eagerly sought by those seeking beauty and solitude. Wildflowers, berries, clear waters, and curious wildlife were abundant everywhere just minutes from downtown Rapid City. The area is unique in that most of these natural parks are easily accessible and remain virtually unspoiled. (Courtesy of the Bell collection.)

This is what tenderfeet longed for—wide open spaces and tantalizing campfire vittles. The 1930s were the era of the dude ranch, made popular by the new craze of western movies. With a great climate suited to sleeping outdoors under the stars, the Black Hills were the perfect destination. (Courtesy of the Bell collection.)

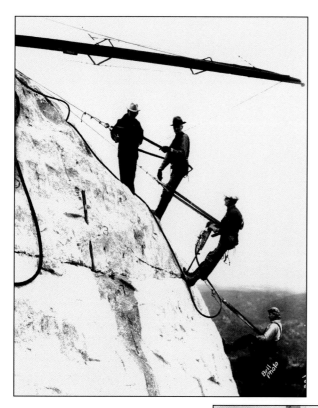

Back at Mount Rushmore, sculptor Gutzon Borglum oversees three workers suspended from the forehead of George Washington. There is no safety net and the men hang precariously by cable and leather harnesses. The front worker and the driller are not young men. Borglum was already 62 when he undertook the project. No fatalities occurred. (Courtesy of the Bell collection.)

Lincoln Borglum, the only son of Gutzon, is standing by a winch used to transport materials from below. Named for his father's hero, Abraham Lincoln, Lincoln Borglum worked for no pay for several years, and it was his duty to regularly rehire the workers his father had fired the day before during fits of temper. (Courtesy of the Bell collection.)

44

The face of George Washington was unveiled on July 4, 1930. The American flag draped over the 60-foot head measured 67 by 39 feet. Gutzon Borglum loved pomp and ceremony, and this would be one of six colorful dedications he organized before its completion in October 1941. He did not live to see it finished, for he died in March of that year. (Courtesy of the Bell collection.)

Promoters devised ways to use Mount Rushmore in their schemes. A grandiose plan of a "Pageant of America" in Rapid City where every man, woman, and child took turns appearing in costume on city streets or in local businesses was paired with the idea of an impressive tableau in an amphitheater setting, performing the history of America as Rushmore rose 25 miles away. It fizzled. (Courtesy of the Bell collection.)

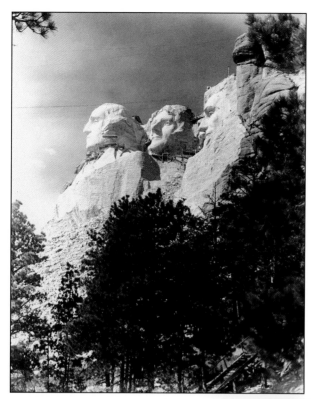

Work progressed in a manner of fits and starts. Erratic funding and the economy caused construction to halt for 7.5 of the 14 years it took to complete Mount Rushmore. Men, mostly unemployed local miners, were glad to get 50¢ an hour. Drillers got 75¢ and carvers $1 an hour. Still they did not always get to collect regularly. (Courtesy of the Bell collection.)

It is August 30, 1936, and a smiling Pres. Franklin Delano Roosevelt speaks into a microphone at the Thomas Jefferson dedication before 3,000 persons. The open touring car was supplied by Black Hills Transportation and is deep enough to conceal the president's crippled condition from the public. (Courtesy of the Bell collection.)

Gutzon Borglum and Oglala Sioux Indians from Pine Ridge Reservation are pictured here about 1935. Learning that the tribe was nearly destitute as winter approached, Borglum petitioned the government in Washington, D.C., for blankets for tribal residents. He was always careful to make sure his name or Mount Rushmore's was attached to any publicity that may have resulted. (Courtesy of the Bell collection.)

This view shows Abraham Lincoln's nose during blasting. A 1,800-foot hose supplied air for the jackhammers. Water was hauled to the site by wagon and taken to the top by a cable and pulley system. Although the work was extremely dangerous, only a few incidents resulted, mainly from lightning strikes, and there were a few broken bones. (Courtesy of the Bell collection.)

A model of Lincoln is hoisted up the mountain for comparison to the work in progress. In the distance, the view extends all the way to the Badlands, 50 miles east. (Courtesy of the Bell collection.)

The scale model bust can be seen to the left of Lincoln's mouth, and rock fractures are clearly visible across the gigantic face. Highlights in the eyes are 16-foot granite logs. Silver and lead are found at the tip of Lincoln's nose, a rare mineral called allanite is located on his cheek, and numerous feldspar crystals appear near his collar. (Courtesy of the Bell collection.)

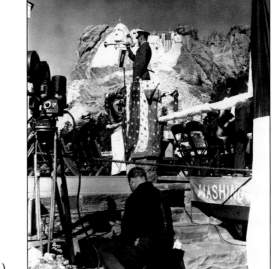

The dedication of Lincoln was held on September 17, 1938, the 150th anniversary of the ratification of the United States Constitution. Today Mount Rushmore remains one of America's most beloved symbols of the principles the nation was founded on. (Courtesy of the Bell collection.)

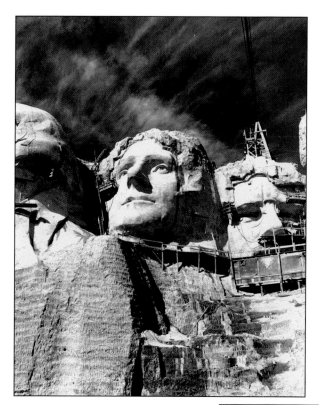

Theodore Roosevelt, champion of national parks and public places, begins to take shape to the right in 1937. Mount Rushmore was put under the jurisdiction of the National Park Service in 1933. Roosevelt's image was dedicated on July 2, 1939. Note the levels of scaffolding and numerous catwalks. The chiseled effects from drilling and dynamiting are visible. (Courtesy of the Bell collection.)

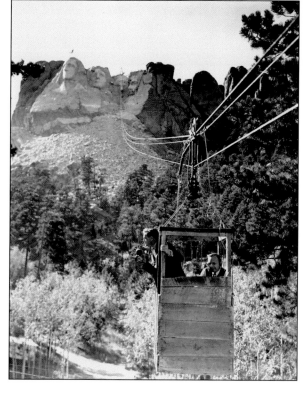

Newsmen from NBC take a bumpy ride to the top of Mount Rushmore in this makeshift cable car. The project remained in the news throughout its construction through broadcasts, newspapers, and newsreels. Schoolchildren saved and sent pennies to help see it become a reality. (Courtesy of the Bell collection.)

The Hall of Records, meant to be a national archive, was begun at the back of Abraham Lincoln's head but never completed. Work stopped suddenly in 1939 after carving only the entrance. (Courtesy of the Bell collection.)

An open-top tour bus brings members and guests of the Black Hills and Badlands tourism association to check on the latest progress. Visitors were as interested in watching the mountain's progression as they were in seeing it finished. A Keystone motel two miles away erected a large coin-operated telescope for its guests to watch the construction. (Courtesy of the Bell collection.)

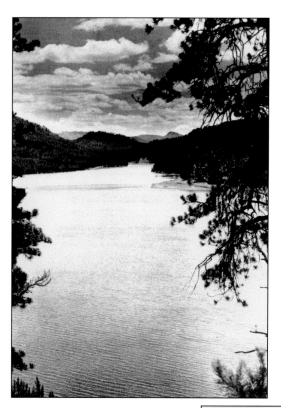

Other areas around Rapid City added to the vacation experience. The 1870s town of Sheridan, the former Pennington County seat, was flooded by the Civilian Conservation Corps to create Lake O' the Pines in the 1930s. Renamed Sheridan Lake, it remains a prime recreational body of water for the region. (Courtesy of Ken Schoenhard.)

Sheridan Lake and its country inns were a popular stop for Sunday chicken dinners and dances. As seen in this advertisement for Carl Leedy's place, spring-fed chickens served family-style were the house specialty. Bernice Musecamp ran Moosecamps, another popular chicken shack, and served up the best in homemade pies. (Courtesy of Bev Pechan.)

Come and Get 'em
Sunday, June 2

Fried Spring Chicken
Real Cream
Good Service
$1.25

Fried Mountain Trout
Western Style
$1.25

... SHERIDAN ...
20 MILES AWAY

From 11:30 Till 3 p. m. — From 5 to 8 p. m.

CARL LEEDY, Prop.

The Oldest Camp in the Black Hills

This trumpeter at Fort Meade, east of Sturgis, sounds the day's routine to 4th Cavalry troopers. The historic fort was founded by U.S. Cavalry 7th Cavalry members after Gen. George Custer's defeat at the Little Big Horn and housed many of that regiment, including the horse Comanche. Fort Meade is also recognized as the place where "The Star-Spangled Banner" became the national anthem. (Courtesy of the Bell collection.)

Officers' wives show off their equestrian skills at a Fort Meade horse show in the 1930s. Entries often were made up of 500–600 horses and riders. In addition to jumping and endurance competitions, Fort Meade had a polo team, musical drill team, and fox hunting club. Bear Butte is in the distance. (Courtesy of Bev Pechan.)

During the Great Depression years, Pres. Franklin Delano Roosevelt's Works Progress Administration (WPA) program gave jobs to the unemployed and sought to create works of public art. Emmett A. Sullivan, a sculptor in Rapid City, was fascinated by the colossal figures undertaken during this era and began his own Jurassic park on Skyline Drive, beginning in 1936. (Courtesy of the Bell collection.)

Although not quite as volatile as Gutzon Borglum, Sullivan was no less artistic in temperament. During a dispute with WPA officials, he walked off the job and, for good measure, took the teeth of one of the dinosaurs with him. Calm eventually prevailed, and the teeth and Sullivan returned to the job. (Courtesy of the Bell collection.)

A distinguished Sioux chief in full ceremonial dress was a favorite subject for Sullivan's prolific souvenir line that favored Native American–related themes to that of his dinosaurs. The name of the elder who poses here with his peace pipe is not known. (Courtesy of the Bell collection.)

The profile on the right is modeled after the chief pictured on page 55. Part of Emmett A. Sullivan's agreement with the City of Rapid City was permission to run a visitor's center and gift shop at Dinosaur Park, which he operated into the early 1960s. He produced numerous wall plaques, ash trays, and bric-a-brac. (Courtesy of the Bell collection.)

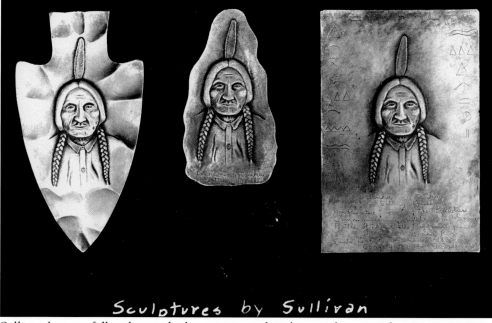

Sculptures by Sullivan

Sullivan became fully taken with the monumental sculptures that were showing up in many parts of the country. In the mid-1960s, he created the massive figure of Christ of the Ozarks in Eureka Springs, Arkansas. These small works are of Hunkpapa Sioux chief Sitting Bull. (Courtesy of the Bell collection.)

Sullivan got the idea of Dinosaur Park after being inspired by the Creston dinosaur, an earlier version of the brontosaurus erected east of Rapid City around 1931. This fellow is 80 feet long and 28 feet high. (Courtesy of the Bell collection.)

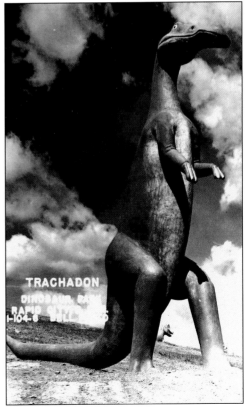

The trachadon measures 33 feet in length and is almost 18 feet long. Originally the figures were painted gray. Somewhere along the line, they became bright green. (Courtesy of the Bell collection.)

This tyrannosaur has terribly fierce teeth but appears to be smiling for its audience. It is 35 feet long and 16 feet tall. (Courtesy of the Bell collection.)

A wide-eyed triceratops is the fourth of five original figures at 27 feet long and standing 11 feet high. A smaller stegasaur rounded out the quintet. Later a dimetrodon and proceatos were added nearby. (Courtesy of the Bell collection.)

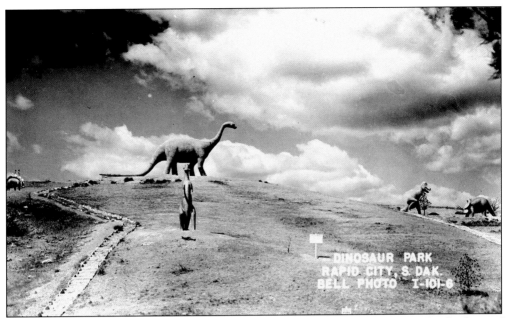

One last look at Dinosaur Park on Skyline Drive shows that the steps are not for the faint of heart. It was coincidence that a nearby excavation site actually unearthed some genuine dinosaur bones when it was previously thought there were no fossil beds in the vicinity. (Courtesy of the Bell collection.)

This petrified woodpile was photographed by Bert Bell, probably sometime in the 1930s. The oddity is located at Timber of Ages petrified forest northwest of Rapid City, and the postcard claims it contains two cords of stacked petrified wood. (Courtesy of the Bell collection.)

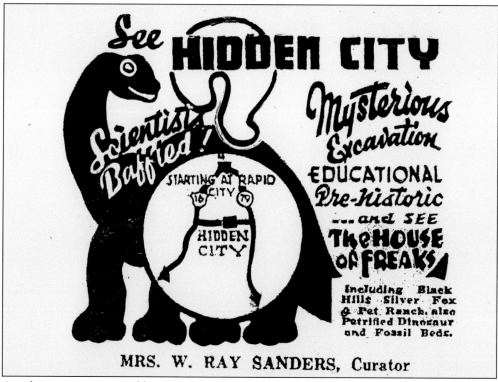

Another curiosity was Hidden City, located southeast of Rapid City. A strange arrangement of limestone resembling the outline of an ancient walled city was discovered, drawing scientists and tourists alike. The origin was not definitely established, but the owners were said to have made a comfortable living off the attraction. The site also contained a zoo and a "house of freaks." (Courtesy of Bev Pechan.)

Sites with live animals always seem to be places of interest. Here the Wild Animal Ranch and Fox Farm advertises it is only four miles southwest of Rapid City and near Canyon Lake. "See 'em alive! By the 100's," says its slogan. (Courtesy of the Bell collection.)

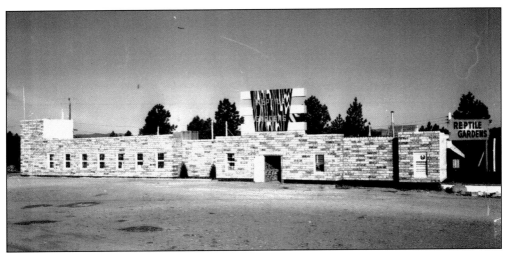

Reptile Gardens was established in 1937 and remains a top visitor draw today. Originally at the top of Skyline Drive, this building's facade contains 48 different varieties of minerals. Founder Earl Brockelsby knew those who made it to the top of the hill would stop before going back down. (Courtesy of the Bell collection.)

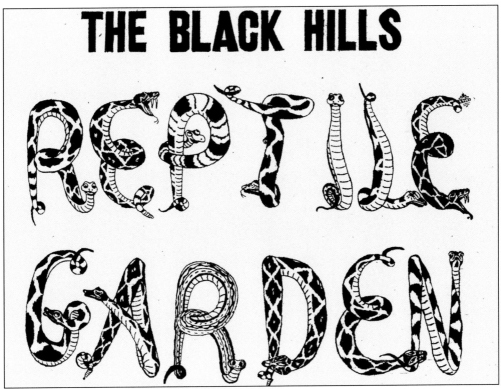

This clever advertisement appeared in the *Rapid City Daily Journal*. Brockelsby also advertised that he would buy "all snakes," paying $1 a pound for them. (Courtesy of Bev Pechan.)

A historical winter count painted on this buffalo hide tells the calendar of events of a particular time. Native American peoples had no written language and relied on pictures to tell their stories of wars, weather, and other events. This detailed example from the Rosebud tribe belongs to the Sioux Indian Museum in Rapid City. (Courtesy of the Bell collection.)

Rapid City's Sioux Indian Museum is one of three such museums in North America operating under the U.S. Indian Arts and Crafts Board through the Department of the Interior. The exquisite beadwork shown here is typical of early-1900s reservation work, when nomadic existence ceased. In 1996, the museum integrated with the Journey Museum. (Courtesy of the Bell collection.)

Four

THE 1940S

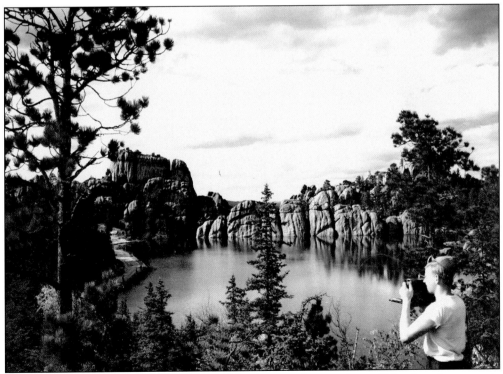

Bill Groethe was 17 years old when this 1941 photograph was taken of him shooting a scenic view of Sylvan Lake with a press camera. (Courtesy of the Bell collection.)

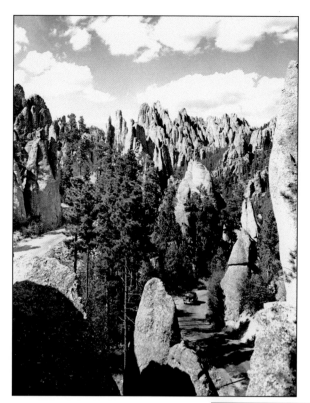

Needles Highway winds through some spectacular rock formations a short distance from Mount Rushmore. Note the different elevations of the road. (Courtesy of the Bell collection.)

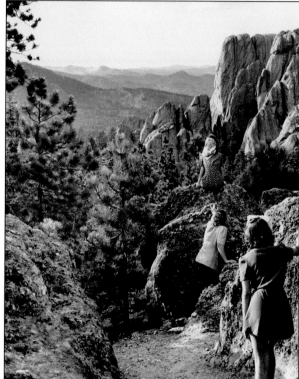

These young ladies are scaling granite outcroppings for a breathtaking view of the Black Hills, about 6,000 feet above sea level. (Courtesy of the Bell collection.)

The Needle's Eye has been a favorite of rock climbers for nearly a century. It is a tradition to reach the top and have one's picture taken. (Courtesy of the Bell collection.)

A Black Hills Transportation caravan from Rapid City parks on a horseshoe curve to view the Cathedral Spires on Needles Highway. (Courtesy of the Bell collection.)

Touring buses made a circuitous route from Rapid City within a radius of 50 miles in either direction. Members of the group wave a western howdy from one of many overlooks at Badlands National Park. (Courtesy of the Bell collection.)

Who has not heard of Wall Drug? The animated cowboy band is from a Denver department store and can still sing a toast to "old Jim Bridger." That is owner Ted Hustead leading the musicians. (Courtesy of the Bell collection.)

Ted and Dorothy Hustead bought the tiny Wall drugstore in 1931 and barely eked out a living until Dorothy suggested putting up road signs offering free ice water. The rest is history. There is a Wall Drug sign on the moon. (Courtesy of Bill Groethe.)

Travelers in the old days required just the basic necessities as this comic postcard from 1941 is quick to point out. (Courtesy of Bev Pechan.)

A good idea at the time went sour for George Hopkins, who parachuted to the top of Devil's Tower just over the Wyoming line in September 1942 on a bet. He could not get down and after causing quite a sensation was finally rescued by mountain climbers who rappelled down the sheer face of America's first national monument. (Courtesy of the Bell collection.)

Hopkins tells a crowd at Rapid City's Range Days Rodeo about his ordeal. He had planned to attempt a record for the number of successive parachute jumps at the celebration but decided to forego the experience. (Courtesy of Bill Groethe.)

Thrill seekers come in all varieties. This young bronc rider is putting on a good show for the Range Days crowd. The contestant appears to be South Dakota's own Casey Tibbs, who as a teenager in the 1940s was billed as "the Kid Wonder." (Courtesy of the Bell collection.)

The Pierre Lodge at Hisega, located just outside Rapid City limits, was a summer getaway for Pierre businessmen and government representatives and was served by the Crouch Line. The name *Hisega* is a combination of the first initials of six female guests. (Courtesy of the Bell collection.)

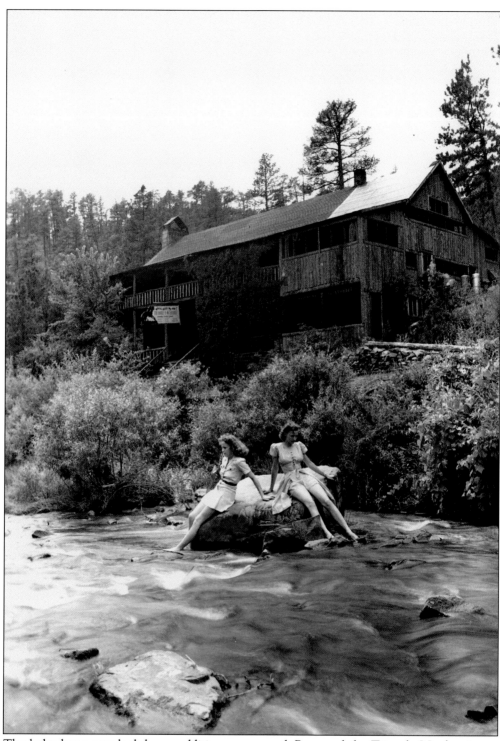

The lodge has a new look by an addition on one end. Renamed the Triangle I Lodge, it was opened to the public, and over a century later, it is still a familiar landmark. Rapid Creek tumbles cheerfully by the front door. (Courtesy of the Bell collection.)

Hangman's Hill is seen from the top of Skyline Drive, looking northwest. The hanging tree may have been replaced by now, but the area remained popular as a lovers' lane, picnic spot, and place to have one's picture taken. (Courtesy of the Bell collection.)

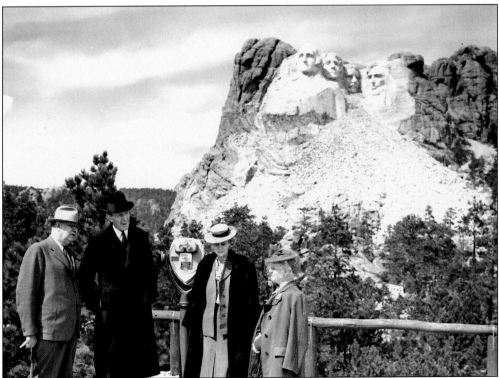

Mount Rushmore is seen from the viewing terrace shortly after its completion in October 1941. Coin-operated viewers brought the faces up close and personal. (Courtesy of the Bell collection.)

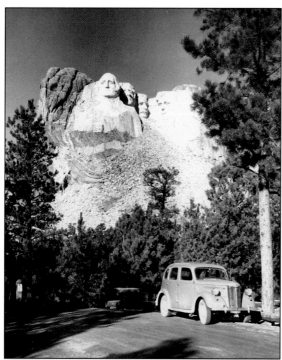

Mount Rushmore National Memorial became America's Shrine of Democracy because it represents the nation's spirit and honors four of its visionary leaders. In the 1940 census, Rapid City had a population of less than 14,000, but nearly 1,000 vacationers a day passed through before gas rationing during World War II. (Courtesy of the Bell collection.)

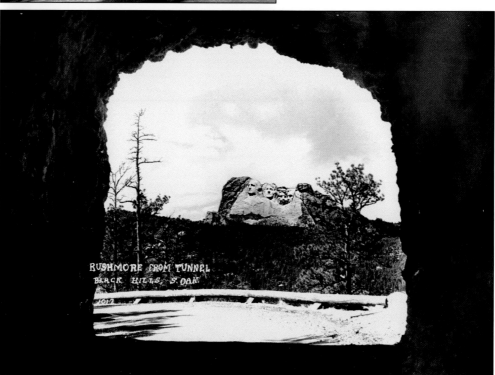

One of Peter Norbeck's innovations, tunnels on Iron Mountain Road frame Mount Rushmore at various vantage points. This earlier Bert Bell photograph demonstrates this engineering marvel, allowing motorists to be near eye level with the carving. (Courtesy of the Bell collection.)

Sylvan Lake Lodge was a showplace when it was built in Custer State Park in 1937. At an elevation of 6,250 feet, it is one of the highest points in the Black Hills. Its ultramodern look is virtually unchanged and remains en vogue today. (Courtesy of the Bell collection.)

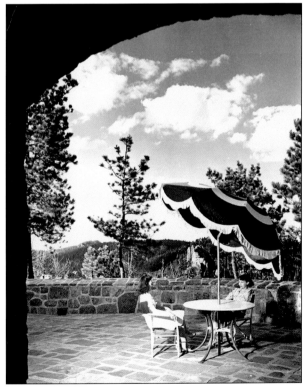

The viewing terrace at Sylvan Lake Lodge is a pine-scented delight. It is easy to see why the area is a vacation paradise. (Courtesy of the Bell collection.)

Perhaps no amount of coaxing will entice these young ladies to take the plunge. Deep mountain lakes are crisp and clear. (Courtesy of the Bell collection.)

BLUE BELL LODGE
BLACK HILLS, S. D.
BELL PHOTO B-5

Riders set out from Blue Bell Lodge in Custer State Park. Horseback riding is a favorite activity for city folks. Blue Bell Lodge was named for the blue bell logo of the Bell Telephone Company, whose personnel built and frequented it. (Courtesy of the Bell collection.)

Gold Discovery Days began in Custer City in 1929 to celebrate its colorful history. This 1941 program repeats the original cover and is dedicated to the memory of Mount Rushmore's creator, Gutzon Borglum, who died in March of that year. (Courtesy of Bev Pechan.)

The pageant of Paha Sapa has been a summertime tradition over the years. Horses and riders were painted in white, gold, blue, green, and brown, representing nature's beauty. (Courtesy of the Bell collection.)

Representing the sun, moon, and stars, gossamer-clad maidens tell the story of the earth's creation in the Black Hills in this performance on Pageant Hill. (Courtesy of the Bell collection.)

These young ladies have formed a living version of the American flag as their part of the pageant. Transportation to and from Rapid City hotels enticed locals as well as out-of-town guests to take in the celebration. (Courtesy of the Bell collection.)

Attacking the wagon train in a rousing climax to each year's Gold Discovery Days, cowboys and Native Americans alike delighted to yipping and whooping while firing their weapons at will. (Courtesy of the Bell collection.)

In 1948, Bill Groethe photographed the last Sioux survivors of Custer's Last Stand in Custer State Park. They were only in their teens back in June 1876 when Lt. Col. George Custer and nearly all his 7th Cavalry were wiped out. From left to right are Little Warrior, Pemmican, Little

Soldier, Dewey Beard, John Sitting Bull, High Eagle, Iron Cloud, and Comes Again. (Courtesy of Bill Groethe.)

In a modern-day Native American encampment with a hand-painted canvas tepee, women and girls are wearing their finest beaded capes, made from thousands of glass seed beads. The unidentified chief wears a bone breastplate and a full eagle feather headdress. (Courtesy of Bill Groethe.)

Ben Black Elk, son of holy man Nicolas Black Elk, beats his drum as part of the elders' honoring ceremony in the park. (Courtesy of Bill Groethe.)

Chief Iron Hail, also known as Dewey Beard, was the last living survivor of the Little Big Horn battle; he was also a survivor of the Wounded Knee Massacre in 1891. Dewey Beard died on November 2, 1955, the anniversary day of South Dakota's statehood. (Courtesy of Bill Groethe.)

Rapid City's Rushmore Motel at 207 St. Joseph Street advertises a "registered restroom" and heated cabins in 1949. It is also a member of AAA and sold Texaco Fire Chief gasoline. (Courtesy of Bill Groethe.)

Nystrom's resort was located on Canyon Lake, three and a half miles southwest of Rapid City. Canyon Lake is now within the city limits and is Rapid City's major outdoor recreational attraction. Dating to the late 1800s, it is not a natural lake. In the 1930s and 1970s, it was redesigned and rebuilt. More recently, a lovely park and trails were added to the area. (Courtesy of Bill Groethe.)

Canyon Lake's swim team members were state champions. Left to right are (first row) Bill Baken, Bob Schumacher, and Art Trompeter; (second row) Tillman Shank, Leroy "Chief" Miller, Juliette Schumacher, Bill Donkin, and coach Carl Loock. (Courtesy of the Carl Loock family.)

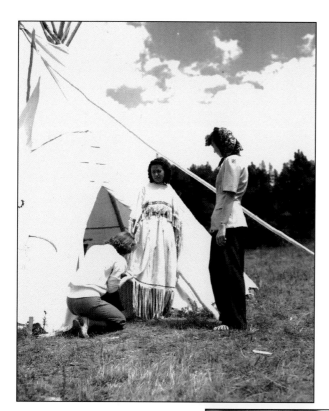

A tourist examines the handwork on this Native American maiden's dress. Native American culture and tradition are of great interest to visitors from all over the world. (Courtesy of Bill Groethe.)

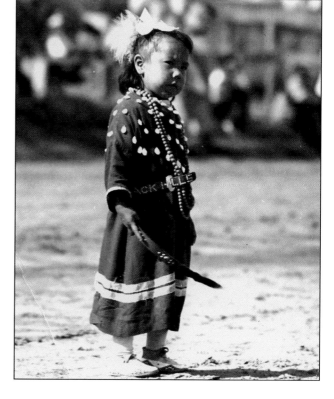

This young Lakota girl seems skeptical of all the activity going on at Duhamel's Sitting Bull Cave just south of Rapid City on U.S. Highway 16. Sioux dances and an encampment were popular attractions at the cave, rumored to have an underground lake with "blind fish." (Courtesy of Bill Groethe.)

Crystalline icicles drip from the ceiling inside Nameless Cave near Rapid City. Much of the underground area of the Black Hills contains a series of caves that remain unexplored, although those discovered are a spelunker's treasure trove. (Courtesy of the Bell collection.)

Called birdbaths, these tiny pools form at an opening in Nameless Cave. Caves are always good to visit in the summertime as they are naturally air-conditioned. (Courtesy of the Bell collection.)

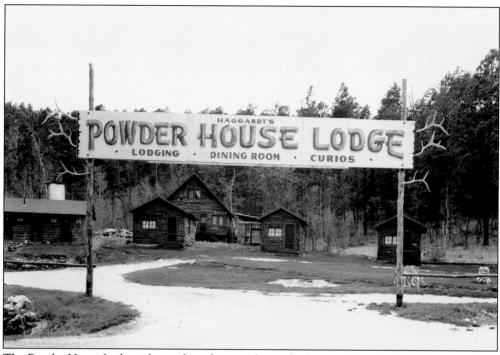

The Powder House Lodge is located on the actual site of a dynamite storehouse near the mining town of Keystone, at the foot of Mount Rushmore. (Courtesy of the Bell collection.)

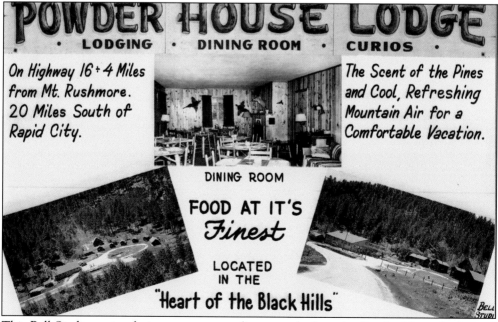

This Bell Studio postcard gives a more complimentary look at the Powder House Lodge and grounds. It remains a popular dining and lodging spot today, often posting No Vacancy signs at the height of the tourist season. (Courtesy of the Bell collection.)

Keeping the Old West alive, Deadwood's stagecoach and its annual Days of '76 celebration are always crowd pleasers. The return of gambling to Deadwood in 1989 to encourage historic preservation revived interest in this legendary place just 30 miles northwest of Rapid City. (Courtesy of Bev Pechan.)

These tourists are showing off perhaps one of the first RVs to hit the road. Postwar availability of gas, tires, and automobiles was an incentive to see the country. (Courtesy of Bev Pechan.)

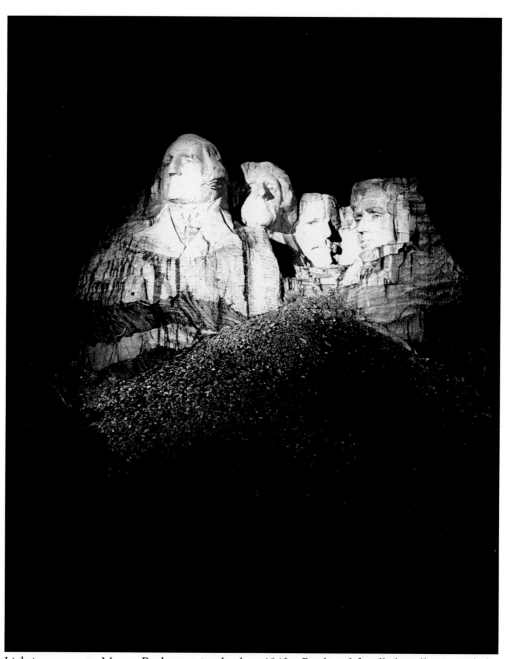

Lighting came to Mount Rushmore in the late 1940s. Banks of floodlights illuminated the fabulous four following an evening interpretive program. In the 1980s, the lighting system was upgraded at a cost of around $500,000. It cost just $950,000 to create all of Mount Rushmore over 14 years. (Courtesy of Bill Groethe.)

Five

THE 1950S

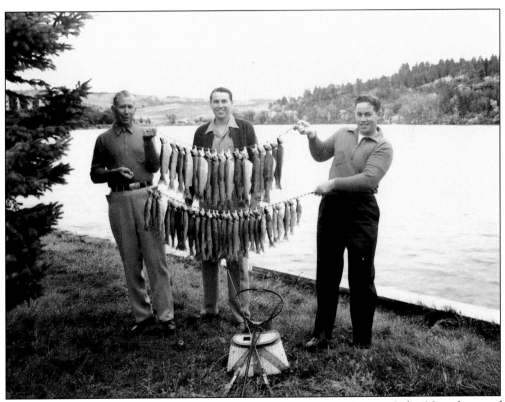

This view shows a fine mess of trout taken at Nystrom's resort on Canyon Lake. Now the proof is in the eating! (Courtesy of Bill Groethe.)

Western hospitality abounds in and around Rapid City. This beautifully decorated guest area welcomes visitors for a memorable vacation. (Courtesy of Bill Groethe.)

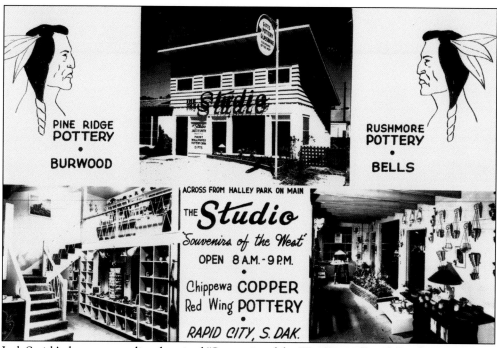

Jack Smith's decorator studio advertised "Souvenirs of the West" at its Rapid City location across from Halley Park and featured Rushmore and Pine Ridge pottery. (Courtesy of Bill Groethe.)

Even food in Rapid City had western, down-home appeal. Rushmore bread makes better cowboys. (Courtesy of Bill Groethe.)

Mills Drug in Rapid City had several locations to serve patrons in the 1950s. To the right are travel cases. First aid supplies are on the left. In between are toothpaste, stationery, and just about everything travelers need. (Courtesy of Bill Groethe.)

Canyon Lake Guest Ranch was operated by Jim McClintock in 1957 when this part of town was still out in the country. It would be difficult to conduct trail rides there today. (Courtesy of Bill Groethe.)

Jensen's Court on Eighth Street in 1949 became Jensen's Pine Cone Motel in 1958 without moving an inch, although a second level was added to the main office and residence. Note the dirt road heading out of town toward Mount Rushmore. The name was changed shortly thereafter to Mount Rushmore Road. (Courtesy of Bill Groethe.)

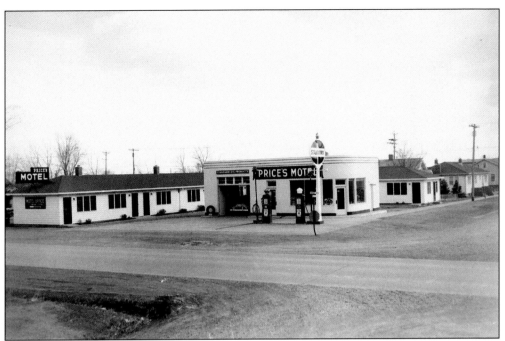

Price's Motel and Standard station was located on Rapid City's East North Street in 1951. This main thoroughfare consisted of a narrow ribbon of concrete that has grown to four lanes today. (Courtesy of Bill Groethe.)

South Town Motel
On Highway U.S. 16 — the Road to Mount Rushmore
RAPID CITY, SOUTH DAKOTA

The South Town Motel on U.S. Highway 16 was modern in its flamingo pink stucco exterior and featured ceramic baths, a patio, and outdoor grill area. U.S. Highway 16 was another name for Eighth Street and Mount Rushmore Road. (Courtesy of Bill Groethe.)

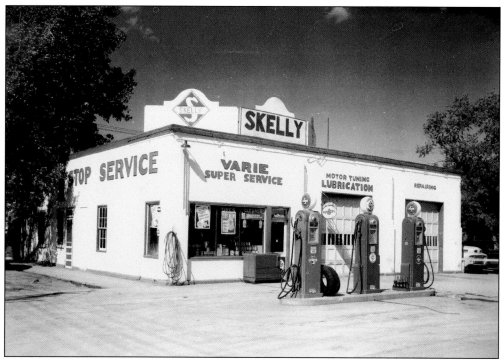

In 1952, Varie's Skelly Super Service served its customers with motor-tuning, lubrication, and general repairs. A drive-over bell hose announced customers at the full-service gas pumps. (Courtesy of Bill Groethe.)

Red's Servicenter at 230 St. Joseph Street had three bays for repairs in 1955. It sold Carter brand gasoline and Goodyear tires. (Courtesy of Bill Groethe.)

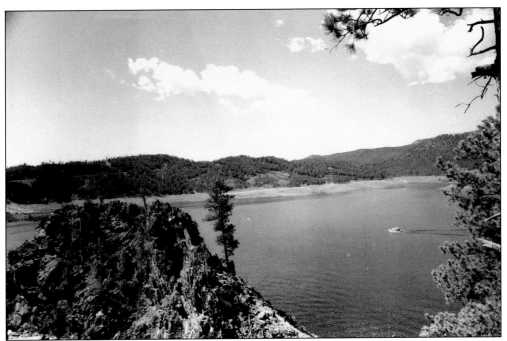

Pactola Lake, completed in 1956, is not only a favorite recreational lake but is a source of water for Rapid City and irrigators to the east. The town of Pactola, meaning "golden fleece," lies submerged at the bottom. Divers find homes just as they were left with dishes in cupboards. (Courtesy of Bill Groethe.)

The beginnings of Interstate 90 at the northern edge of Rapid City appear to be invading pastoral surroundings in this 1959 photograph. The area is now anchored by Rushmore Mall and several shopping centers, motels, and restaurants. (Courtesy of Bill Groethe.)

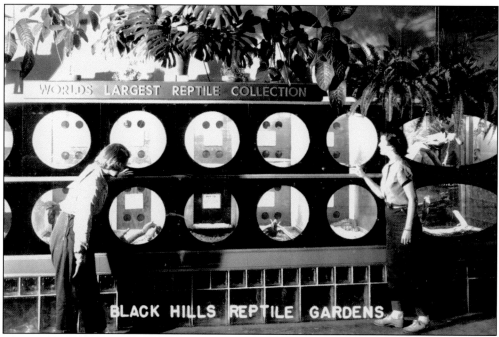

The world's largest reptile collection is on view in climate-controlled cages. The ladies appear to be somewhat cautious. Reptile Gardens later moved to its present location on U.S. Highway 16, which has grown to four lanes of traffic, midway between Rapid City and Mount Rushmore. The number of automobiles parked out front during the summer has been a reliable tourism barometer. (Courtesy of Bill Groethe.)

Not everyone wants a snake coiled around their neck, but the handler seems perfectly at ease. Besides reptiles, the family attraction at its present location features a botanical garden, birds of prey show, and children's area. Methusulah, the ancient Galapagos tortoise, is still a youngster at 120-plus years. (Courtesy of Bill Groethe.)

BLACK HILLS REPTILE GARDENS

Snakes alive! A ball of poisonous predators winds around a tree and one another. The young lady looks like she is touching the colorful back of one of the exotic reptiles, but it is an illusion. (Courtesy of Bill Groethe.)

Hill City's 1880 train chugs along Black Hills Central Railroad tracks between Hill City and Keystone. Note the rails for both narrow- and standard-gauge engines. The excursion line brings railroading adventures back to the Black Hills and has operated as a tourist attraction since 1957. (Courtesy of Bev Pechan.)

Klondike Casey, engine No. 69, takes on passengers at its Hill City depot. Other engines used carried the colorful names of *General Custer, Sitting Bull, Chief Crazy Horse,* and *Natalie,* the little ore train from the northern Black Hills now at Crazy Horse Memorial near Custer. (Courtesy of Bev Pechan.)

Repeat world champion South Dakota cowboy Casey Tibbs gives spurs to bareback bronc Easy Money at the Match of Champions invitational rodeo in Nemo in 1955. The annual event was held at the famed Ox Yoke Ranch, 20 miles northwest of Rapid City, and drew top performers, movie stars, and other celebrities. (Courtesy of Bev Pechan.)

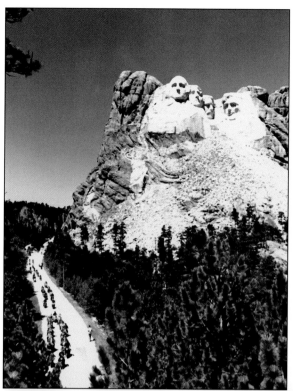

Mount Rushmore is a favorite must-see destination for visitors of all types. Here the Jackpine Gypsies motorcycle club of Sturgis passes below the memorial. Many bikers are war veterans, and a day is set aside at the annual Sturgis biker rally to pay their respects at the mountain that honors America's freedom. (Courtesy of the Bell collection.)

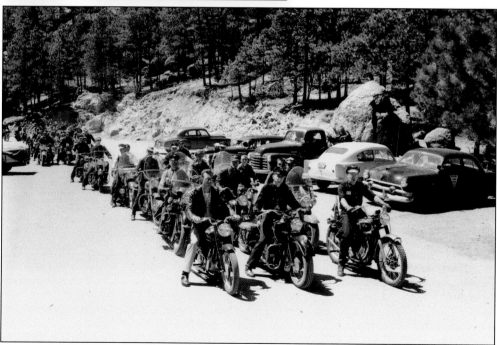

Members of the Jackpine Gypsies are leaving the parking area of the sculptor's studio at the foot of the four faces in the early 1950s. The Sturgis rally dates to 1938, and the annual ride to Mount Rushmore has been a tradition since the group was organized. (Courtesy of Bill Groethe.)

Six

THE 1960s

Three Forks Inn between Sheridan Lake and Hill City has been a local fixture for years, catering to local and traveling customers and sportsmen. After more than a half century at the same location, a new building there now serves the junctions leading to Hill City, Rapid City, and Deadwood in an area of vacation homes. (Courtesy of Bev Pechan.)

A huge log of fossilized wood invites inspection at Timber of Ages petrified forest near Piedmont, 16 miles northwest of Rapid City. (Courtesy of Bill Groethe.)

Petrified wood lies scattered through a forested part of Timber of Ages park. The examples appear to have different grains and textures. (Courtesy of Bill Groethe.)

The Wall Drug dinosaur marks the entrance to the town of Wall and Wall Drug. It was created by the workers from Dinosaur Park in 1960 as a replacement for banned highway billboards. Its red eyes shine as a beacon at night to guide travelers along Interstate 90. (Courtesy of Bev Pechan.)

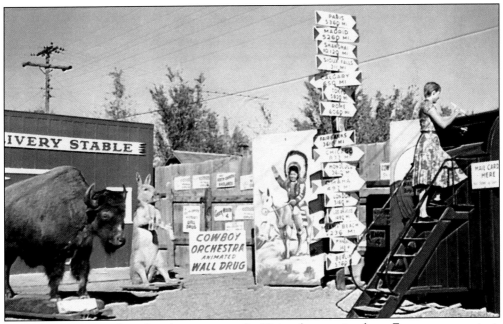

Wall Drug's courtyard is a kitschy come-on of oddities that tourists love. From a meager start, the Wall Drug complex now comprises 75,000 square feet. The woman is climbing the ladder to mail postcards. (Courtesy of Bev Pechan.)

The historic back bar at Rockerville's Gaslight Saloon was said to have come from an early Rapid City hotel. Rockerville, an authentic gold mining town 12 miles south of Rapid City on U.S. Highway 16, had a population five times that of Rapid City in the 1880s. (Courtesy of Bev Pechan.)

Rockerville Gold Town, pictured here in the 1960s, still looked the part of a rip-roaring mining camp. In the old days, a 17-mile-long flume from the Sheridan area was built to bring water to the diggings, but it leaked. Fortunes went as quick as they came. (Courtesy of Bev Pechan.)

104

Stuart's Castle in Rockerville was a widely known attraction in the form of a miniature 15th-century castle. Created by Rev. Stuart A. Parvin, the 16 rooms contained scaled-down versions of elaborate furnishings, using one inch to the foot, the same ratio Gutzon Borglum used at Mount Rushmore. (Courtesy of Bev Pechan.)

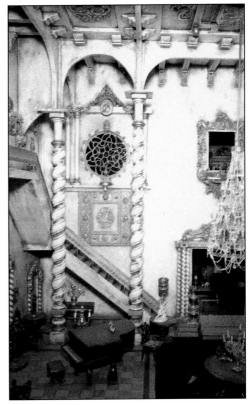

The attraction operated into the 1980s, when the collection was removed and the purple and gold building that housed it abandoned. A few years ago, heavy snows caused the roof to fall in. (Courtesy of Bev Pechan.)

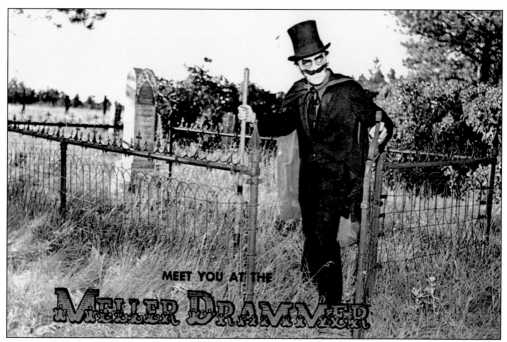

Rockerville's Meller Drammer was a big hit for several seasons with the staging of productions such as *The Drunkard and Deadwood Dick*. Of course, it was the custom to boo the villain. (Courtesy of Bev Pechan.)

The stagecoach stopped at the front door of Rockerville's Pancake House in the 1960s. The team of four matched horses appear to be the spirited kind. The re-created town fell into disuse in the 1980s and with the exception of the Gaslight Saloon has now become a ghost town for the second time. (Courtesy of Bev Pechan.)

Ben Black Elk spent many years at Mount Rushmore posing for pictures. He estimated he had been photographed over two million times. In 1961, his was the first face beamed around the world via the Telstar satellite. (Courtesy of Bev Pechan.)

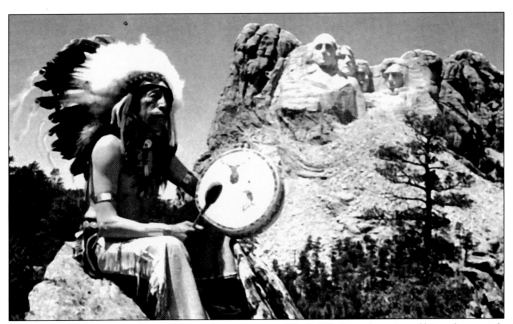

As a Native American ambassador on the mountain, Black Elk shared stories of his culture with persons from all over the world. (Courtesy of Bev Pechan.)

The Interstate 90 overpass at the northwest corner of Rapid City is nearer to being a reality by the early 1960s. In 1965, Rapid City had a population of 48,800 and hosted 3,118,432 tourists. (Courtesy of Bill Groethe.)

Seven

THE 1970S

Storybook Island is shown in the 1970s. When it first opened to the public on August 15, 1959, over 10,000 persons flooded the tiny park. Built and maintained by the Rotary Club of Rapid City, Storybook Island becomes a festival of lights over the Christmas holiday season. (Courtesy of Jane and Ron Mincks.)

This young buffalo cow seems to have a surprised expression. Bison, or buffalo, are numerous in South Dakota today. The Custer State Park herd is one of the largest in North America. It is rounded up each fall, and surplus animals are auctioned, which is now a major tourism event. (Courtesy of Bev Pechan.)

Bighorn sheep are not native to the Black Hills, but since having been introduced in the 1920s, they have adapted well to their surroundings. (Courtesy of Bev Pechan.)

The granddaughter of Bill and Alice Groethe, Emma Mincks pillows her head on Dopey, one of the Seven Dwarfs at Storybook Island. Mincks is now a senior at college. (Courtesy of Jane and Ron Mincks.)

More Groethe grandkids are hiding in Yogi Bear's famous picnic basket on this Storybook Island outing. Yogi looks good in middle age. (Courtesy of Jane and Ron Mincks.)

Wyoming artist Bernard P. Thomas created this 180-foot panoramic mural, called a cyclorama, depicting the chronological history of America in 1975. It is a downtown Rapid City attraction, located in the Dahl Fine Arts Center. (Courtesy of Bill Groethe.)

The cyclorama begins with America's discovery and traces its immigrant element and Native American culture through all major events, ending with the space age. The lower portion of this art-in-the-round portrays the nation's scenic wonders. (Courtesy of Bill Groethe.)

George Washington looks out over the Black Hills as if to reflect on all the activity that the carving of Mount Rushmore has brought to the region. Rapid City remains the headquarters for tourism that contributes enormously to the local economy in the western portion of South Dakota. (Courtesy of Bev Pechan.)

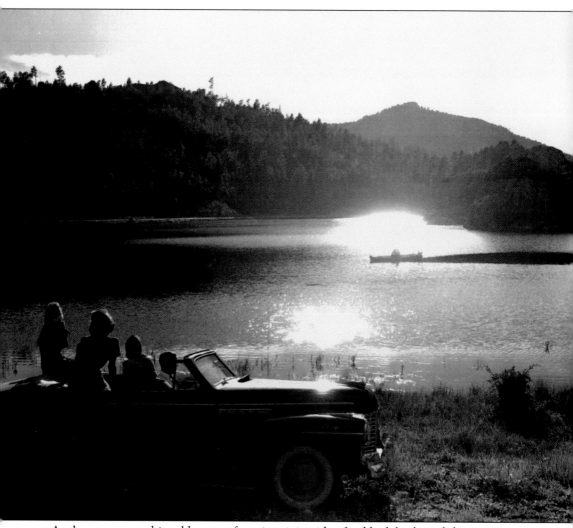

As the sun sets on this golden age of tourism, it is with a fond look backward that times spent in America's vacation paradise are remembered. It was a special time in a magical place. (Courtesy of the Bell collection.)

Eight

THE LATE CENTURY

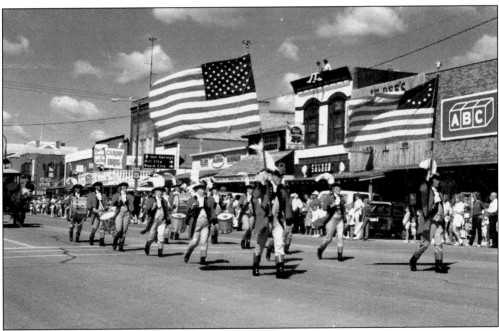

Hill City's fife and drum corps is pictured in Revolutionary War costumes during a Gold Discovery Days parade in the late 1980s. Organized by Korczak Ziolkowski, visionary and sculptor of nearby Crazy Horse Memorial, in 1949, the colorful group played every Fourth of July at Mount Rushmore for many years. Once disbanded and again regrouped in 1975, aging members hung up their uniforms for good as the century closed. (Courtesy of Bev Pechan)

Leading up to the new century, an extensive renovation program began at Mount Rushmore's grounds. A museum facing the memorial has added extensive displays to explain in photographs the history of the carving of Mount Rushmore. (Courtesy of Bill Groethe.)

Since helping Bert Bell shoot the first scenes of Mount Rushmore, Bill Groethe has faithfully returned to the mountain again and again to record the history taking place there. He could perhaps be considered its official photographer. (Courtesy of Bill Groethe.)

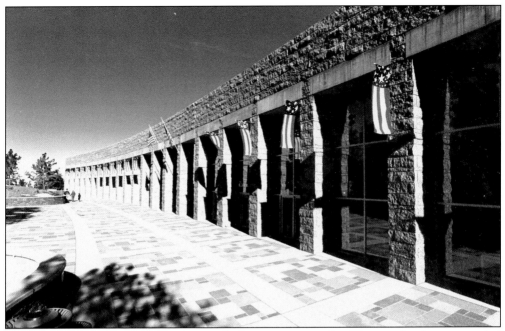

Pictured is the viewing terrace at Mount Rushmore as it is today. The area has been expanded to allow for increases in visitation. Facing the sculptures, the amphitheater is below and a presidential pedestrian trail has been added for walking around the base of the memorial. (Courtesy of Bill Groethe.)

The great wall of Mount Rushmore's museum features giant photograph murals and examples of machinery and tools used in construction. Lighted display cases reveal memorabilia pertaining to Gutzon Borglum, correspondence, and documents. (Courtesy of Bill Groethe.)

The fire dive was a death-defying act performed on special occasions at Marine Life aquarium just south of Rapid City in 1983. Here diver Cal Loock has been set on fire as a human torch for a swan dive into the pool 35 feet below. Loock, who resides in Keystone, is an Acapulco cliff-diving champion and a member of the Great American High Dive team. (Courtesy of Cal Loock.)

Cal Loock's father, champion swimmer Carl Loock, was in the Marine Life audience in 1983 and, at age 70, agreed to dive with his son to the delight of onlookers. The senior Loock is on the right. Cal Loock was a regular performer at the attraction. (Courtesy of Carl and Cal Loock.)

Playful dolphins frolic at Marine Life. The water show was a popular place for families to bring youngsters, who sometimes got to be a part of the show and received a coveted certificate of participation. (Courtesy of Bill Groethe.)

This engine is shown taking on water at the 1880 train station in Hill City and is one of the locomotives still being used by Black Hills Central Railroad. Train excursions in the Black Hills are every bit as popular today as they were in the last century, and this line continues to run on a portion of the same track in use over 100 years ago. (Courtesy of Bev Pechan.)

Popular souvenir items of the last century, these Skookum dolls are now eagerly sought after collectibles that might be found in Rapid City's many antiques shops and flea markets, an added niche to today's tourism experience. (Courtesy of Bev Pechan.)

A flyover highlights Ellsworth Air Force Base's annual air show. Ellsworth, established 20 miles east of Rapid City during World War II, continues to be an important military base of operations as home to B-1 bombers and a former strategic air command center. Nearby, a Minuteman II missile installation has also been opened to the public. (Courtesy of Bill Groethe.)

This military airplane is on display to visitors at Ellsworth Air Force Base. A museum on the grounds tells of the area's military involvement. The Stratobowl, a natural depression south of Rapid City, was the site for launching balloons Explorer I and II in 1934 and 1935. Besides setting an altitude record, data collected on the flights launched America into the space age. (Courtesy of Bill Groethe.)

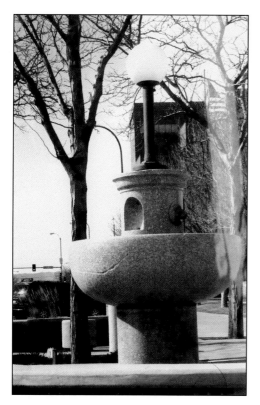

A popular attraction in downtown Rapid City in the early 1900s was this granite fountain erected in the center of Seventh and Main Streets. The fountain was a gift in the early 1900s from a philanthropist animal lover who donated several such fountains around the country through various humane societies. Horses could drink from the fountain, which also had basins below for dogs. Removed prior to 1920, it was recently rediscovered, restored, and placed near its original location. (Courtesy of Bev Pechan.)

In 1991, historic downtown Rapid City launched itself into the forefront with the introduction of the first four life-size American presidents cast in bronze for placement on street corners. The City of Presidents project will portray all presidents by 2011, with 24 currently completed. This is Martin Van Buren. (Courtesy of Bev Pechan.)

Popular Ronald Reagan stands at the corner of Sixth and St. Joseph Streets in front of Tally's restaurant. It is not unusual to see visitors being photographed with the presidents. Each statue costs $50,000 and showcases the talents of a regional artist. (Courtesy of Bev Pechan.)

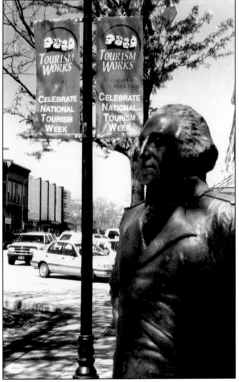

George Washington, the first president to be introduced, stands in a place of honor in front of the landmark Hotel Alex Johnson in downtown Rapid City. Appropriately, the banners above draw attention to National Tourism Week. (Courtesy of Bev Pechan.)

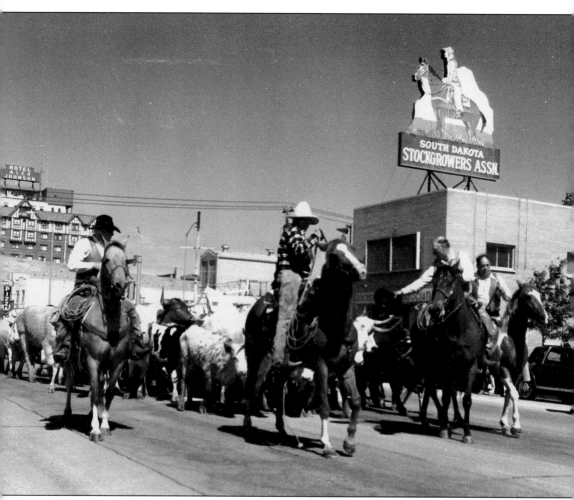

Bringing it full circle, the 100th anniversary of the South Dakota Stockgrower's Association had a big centennial celebration in Rapid City in 1991 to commemorate the Stockman's Days of a century ago. The Hotel Alex Johnson, left, has been an eyewitness to much of Rapid City's fascinating history. (Courtesy of Bev Pechan.)

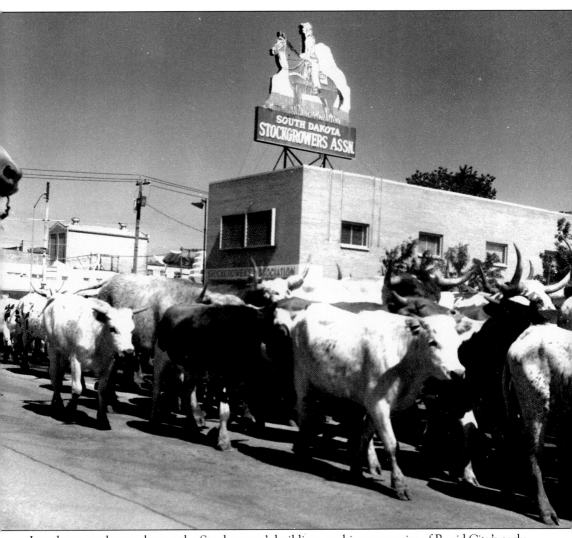

Longhorn cattle parade past the Stockgrower's building, evoking memories of Rapid City's early days as a bustling cow town. No matter how much things change, some will remain the same. (Courtesy of Bev Pechan.)

Fireworks at Mount Rushmore are a recent addition during Independence Day activities. Televised worldwide, the event draws 10,000 to 20,000 persons annually. The gigantic display can be seen for miles in all directions, prompting locals to grab a few sandwiches and head for the highest elevations near home. (Courtesy of Bev Pechan.)

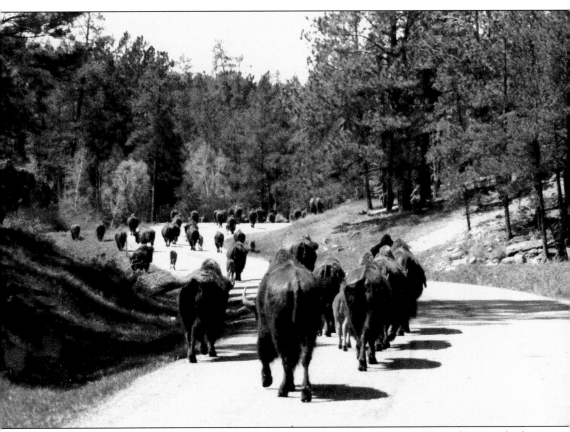

Heading home at the end of a busy day, this herd of buffalo has probably been photographed by tourists hundreds of times since morning. Tomorrow will be another time to pose for the cameras. (Courtesy of Bill Groethe.)

Discover Thousands of Local History Books
Featuring Millions of Vintage Images

Arcadia Publishing, the leading local history publisher in the United States, is committed to making history accessible and meaningful through publishing books that celebrate and preserve the heritage of America's people and places.

Find more books like this at
www.arcadiapublishing.com

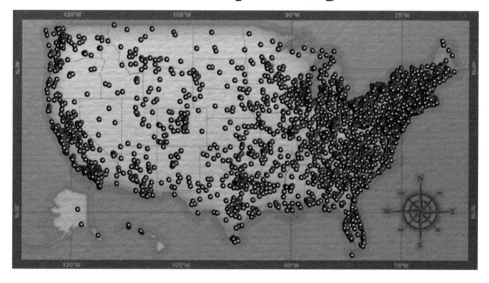

Search for your hometown history, your old stomping grounds, and even your favorite sports team.